COLORING BOOK:

PALEOFAUNA

Color and Learn the History of 50 Prehistoric Animals.

With Accurate Description of Each Animal.

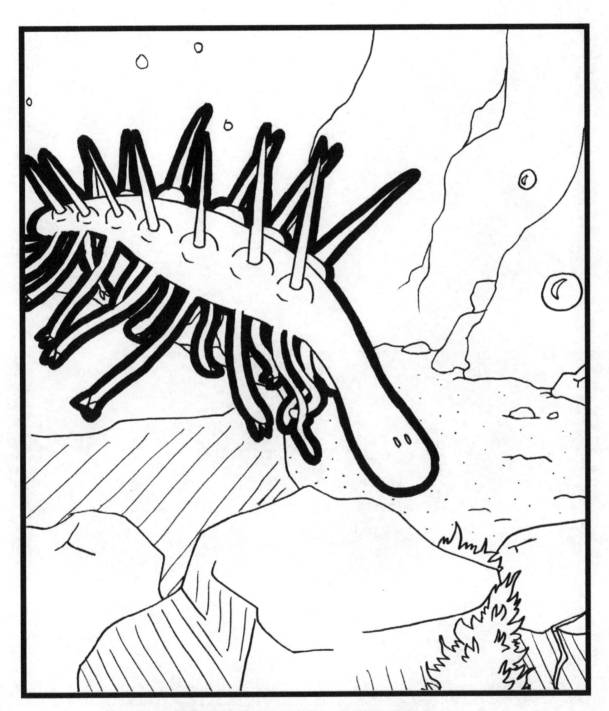

HALLUCIGENIA

520 MYA, Middle Cambrian, Canada, China

Upon discovery, this invertebrate baffled researchers, and many different reconstructions of this creature exist today. Some label it a velvet worm ancestor, some call it an arthropod, while others are content with it being a lobopod, a worm with legs. Early depictions of this animal were reconstructed upside down and back to front, adding to its strange history since discovery.

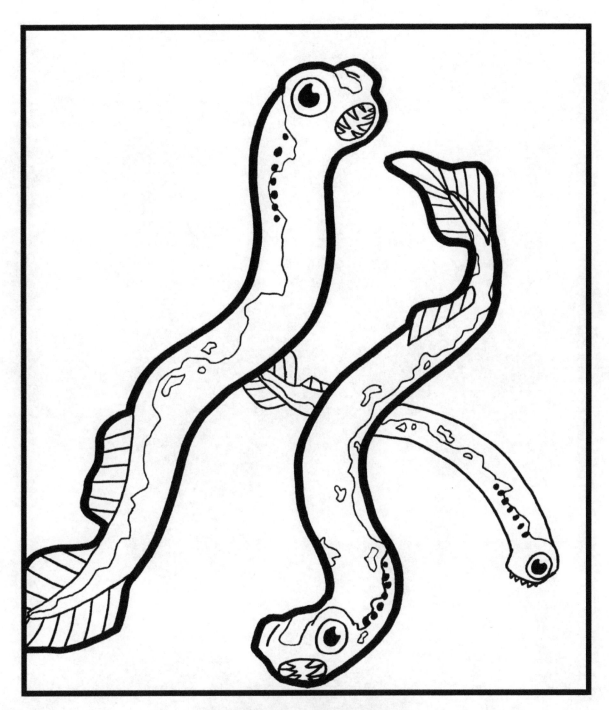

CONODONT

520 - 200 MYA, Late Cambrian to Late Triassic, South Africa, Canada, United States, Scotland

Despite the teeth being one of the only parts of the body that could be easily preserved, fossils of these early vertebrates have been found all over the world, and are commonly used to identify geologic periods. They were eel-shaped, and ranged in length from one to forty centimeters. Some species ate plankton, some had grasping teeth, but overall, they were not fit for high speed chases.

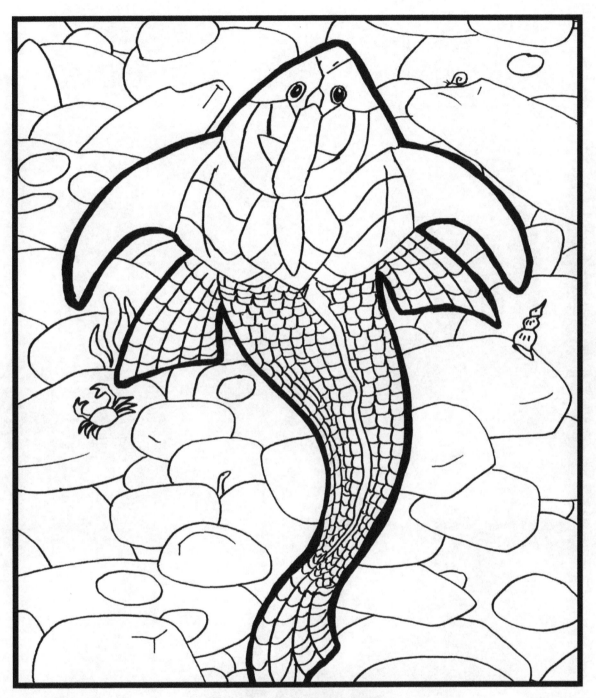

LUNASPIS

409-402.5 MYA, Early Devonian, Australia, China, Germany

This placoderm lived in shallow marine environments, and was given the name of "moon-shield" for the crescent shaped plates on either side of the head. These hunters were active swimmers, and had long, whiplike tails.

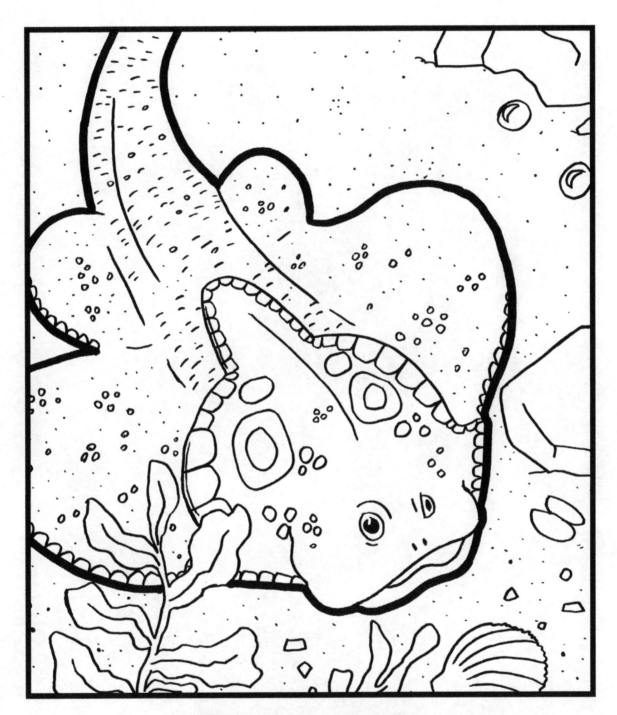

GEMUENDINA

409 - 402 MYA, Early Devonian, Germany

Gemuendina was a bone-plated placoderm fish with the outward appearance of a modern stingray. Growing up to a meter long, it dwelled at the bottom of the sea, suctioning up small prey that swam too close to its upturned mouth.

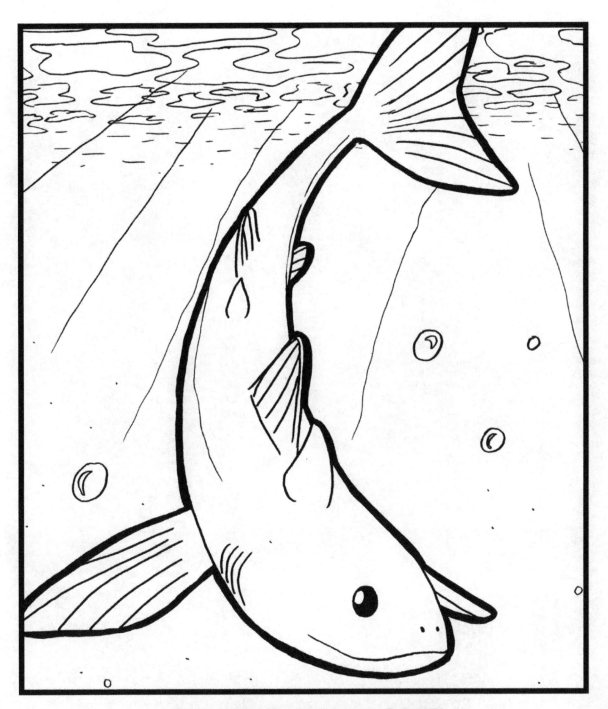

CLADOSELACHE

385 - 359 MYA, Late Devonian, United States and Canada

This was an early shark that lacked scales over most of its body, preserving them on the fins, mouth, and around the eyes. This shark was a fast and agile swimmer, and it had to be, for not only did it hunt fast prey, it was a target of another large predator: the armored fish Dunkleosteus.

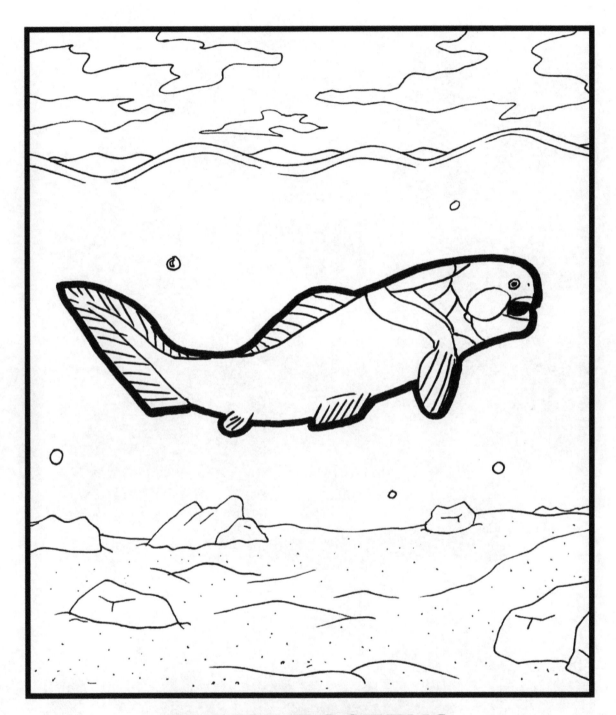

DUNKLEOSTEUS

382 - 358 MYA, Late Devonian, Morocco, Belgium, Poland, Canada, and United States

The largest member of this carnivorous genus an apex predator; it was 6 meters long and weighed up to a ton. As a placoderm, it was a fish with plenty of bony plates in its body, and instead of teeth, it had a pair of bony plates that resembled a beak.

It was a slow, but powerful swimmer.

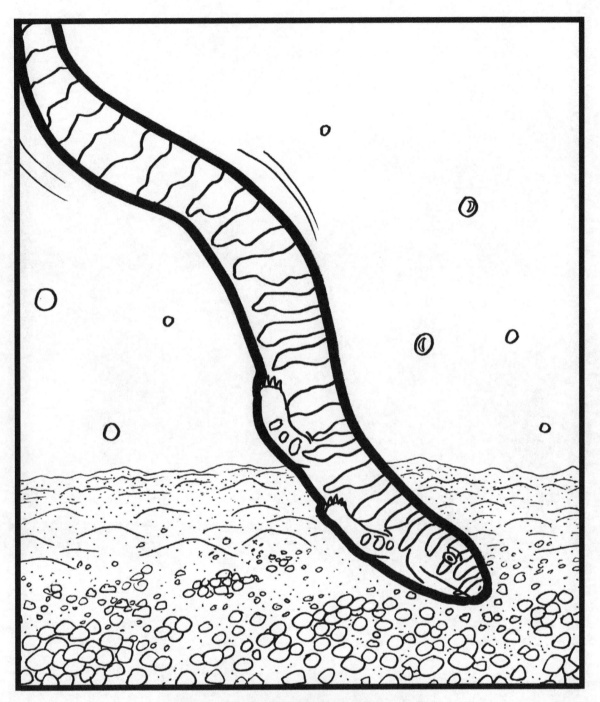

UROCORDYLUS

318 - 314 MYA, Late Carboniferous, Ireland

This was a small amphibian that could reach a length of about 15 centimeters, most of which was part of its tail.
It used this long, paddle-shaped tail to swim through the waters in which it lived, but probably ventured on land from time to time.

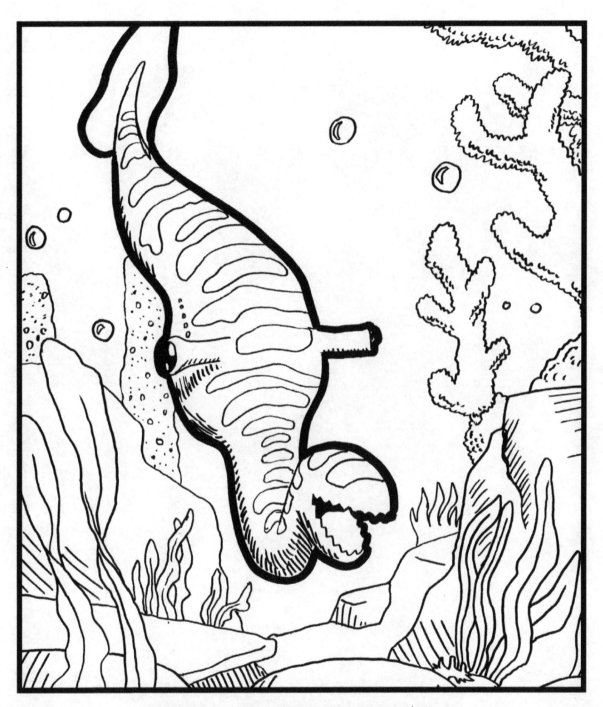

TULLIMONSTRUM

300 MYA, Late Carboniferous, United States

Though originally thought to have been some sort of marine invertebrate, new research has suggested that this stangely-built creature was actually a basal vertebrate related to lampreys. Fossil specimens have also preserved pigments on the animal, showing where darker patches would have been.

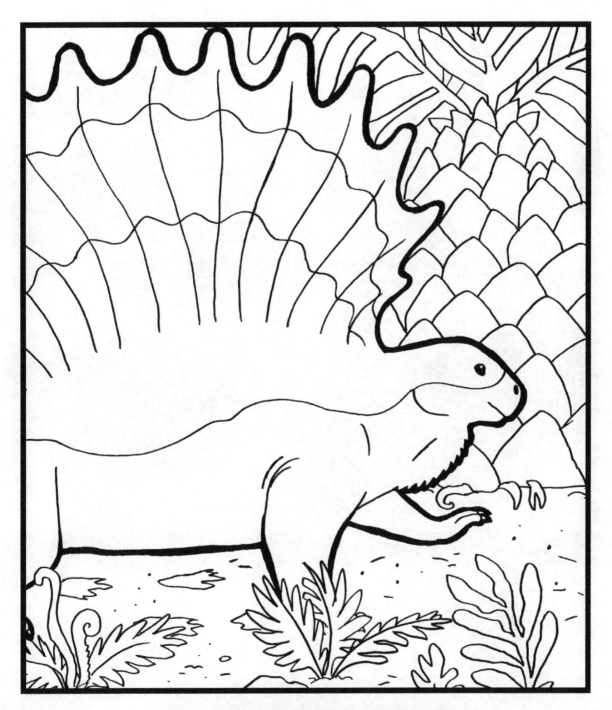

EDAPHOSAURUS

300 - 280 MYA, Late Carboniferous to Early Permian, Germany, Czech Republic, and United States

These animals were some of the earliest large, plant-eating amniote tetrapods. Like many other sail-backed animals, many different uses were proposed for the sail, including but not limited to: courtship, thermoregulation, fat storage, muscle support, camouflage, protection against predators, and species recognition. It's likely the sail had more than one purpose.

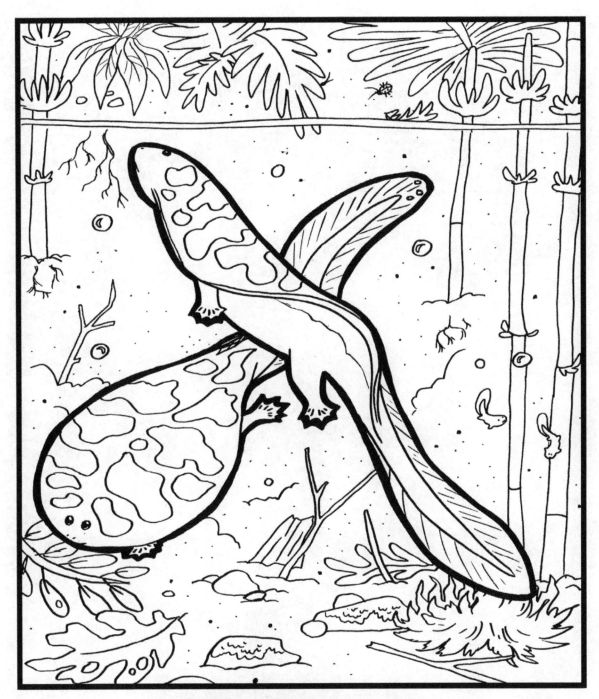

DIPLOCAULUS

299-251 MYA, Permian, North America

This long-lasting genus of amphibians were around for nearly the entire Permian. They have been known to dig burrows, which helped it cope with long periods of drought. The purpose of such an oddly-shaped skull has been thought to be several things: to make it more difficult to be eaten, as an attachment for a membrane, and/or to make the animal more hydrodynamic.

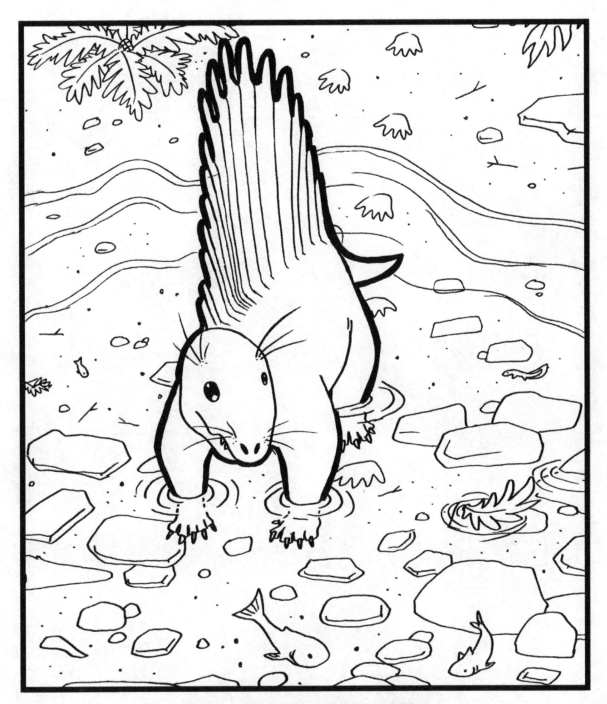

DIMETRODON

295-272 MYA, Early Permian, United States and Germany

Despite being lumped in the same category as dinosaurs in countless media, Dimetrodon were not only around 40 million years before any dinosaur, but were also more closely related to mammals. The group it's in, Synapsida, also contains mammals as we know them today, and is separate from Sauropsida, which include dinosaurs. The sail-back was likely used in courtship, but probably had other uses as well.

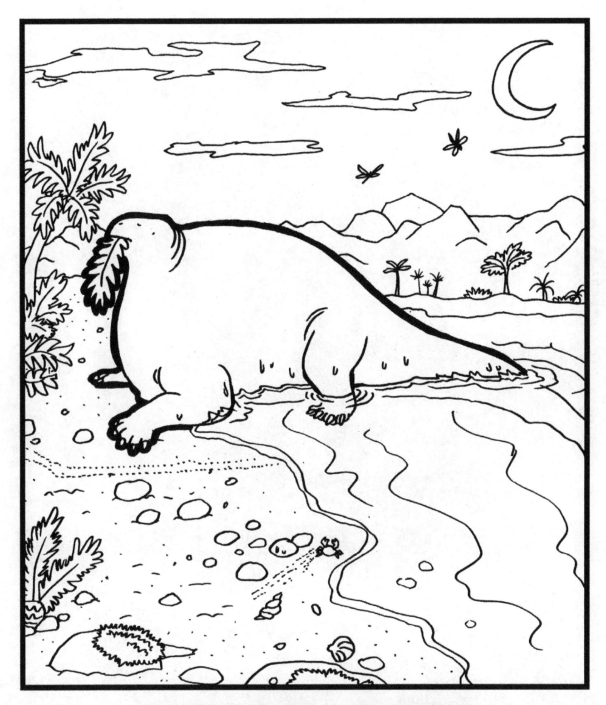

COTYLORHYNCHUS

279 - 272 MYA, Early Permian, United States

At 6 meters long, and with a body this massive, this was one of the largest synapsids of the early Permian, and might have been partly aquatic. The hands could have been used as paddles as the animal swam through water, like a turtle. Its teeth were similar to an iguana's, and probably needed to spend a lot of its time eating in order to sustain such a large form.

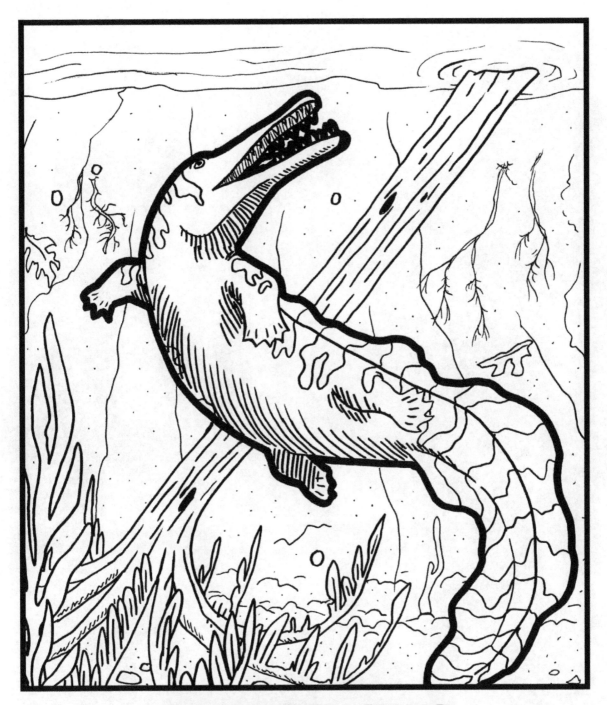

PRIONOSUCHUS

270 MYA, Middle Permian, Brazil

This gharial-like, piscivorous amphibian lived in a humid, tropical environment. Most of them have been found to be between 2 and 2.5 meters long, but there was one individual specimen that had such a huge skull, the body would have been 9 meters long. If indeed this large, it would been one of the largest predators of the Permian.

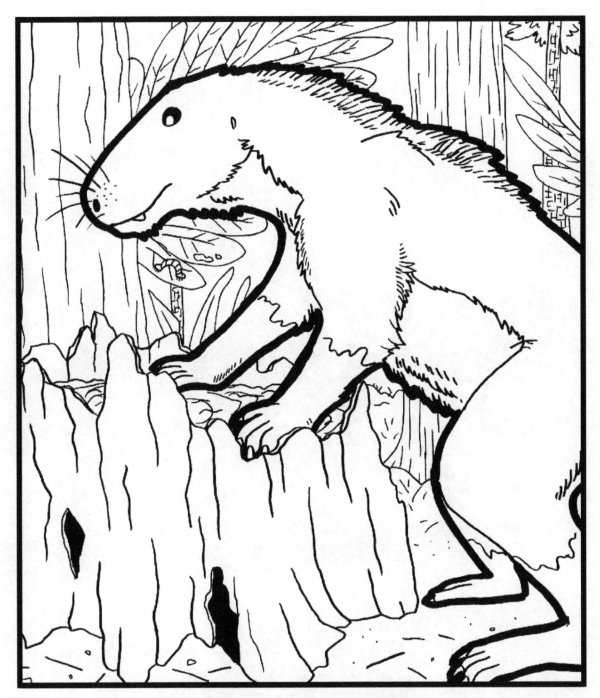

LYCAENOPS

270-251 MYA, Mid to Late Permian, South Africa

This "wolf-face" was a carnivorous therapsid, and were about a meter long, and weighed about 15 kilograms. Being in the same group as mammals, they were likely covered in fur, and could hold their legs under their body rather than splayed to the sides. This allowed them to outrun other animals.

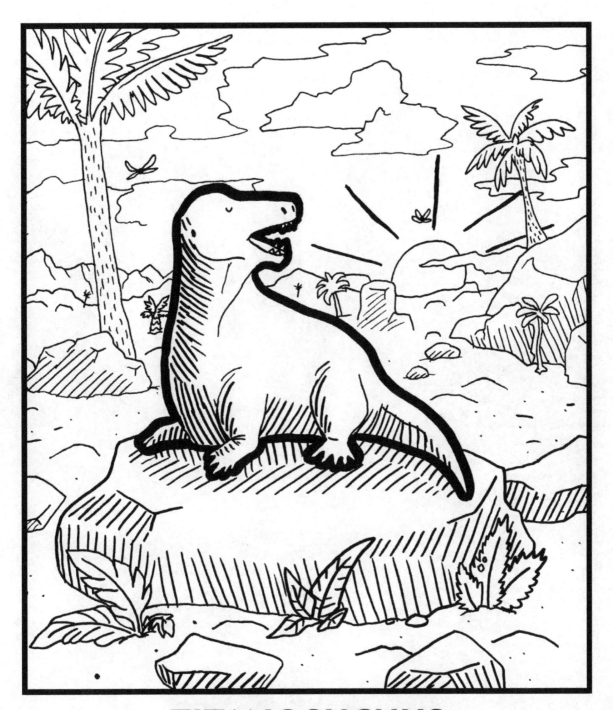

TITANOSUCHUS

265 MYA, Mid Permian, South Africa

Though usually depicted as a carnivore, it has been argued that this therapsid could just as well have used its mouth full of incisors to go at plants instead. It depends on how the fossils are interpreted, and a misinterpretation of what the teeth belonged to led to it being named a "titan crocodile." Though not related to any crocodiles, it did descend from the same group that contained animals like Dimetrodon.

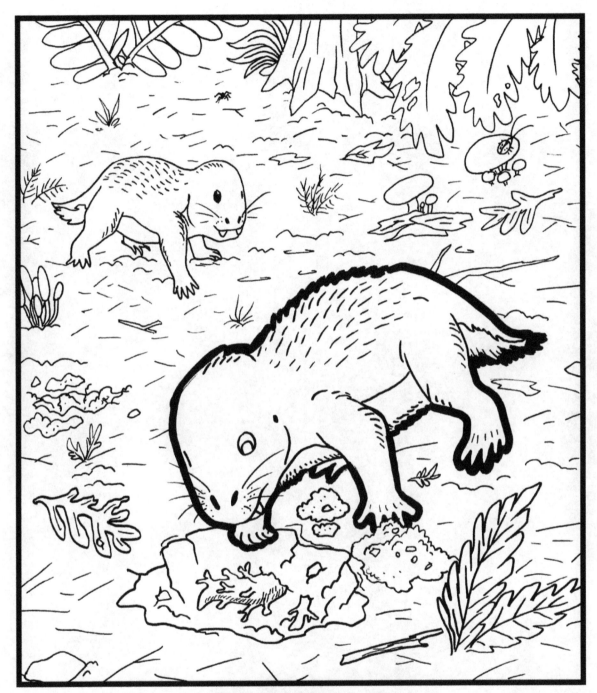

ROBERTIA

265 - 260 MYA, Middle to Late Permian, South Africa

This was a small, early dicynodont, a group of herbivorous synapsids that had a pair of tusks. The horny beak was capable of severing tough plant matter such as stems or twigs. It was only about 20 centimeters long, and probably burrowed in the ground.

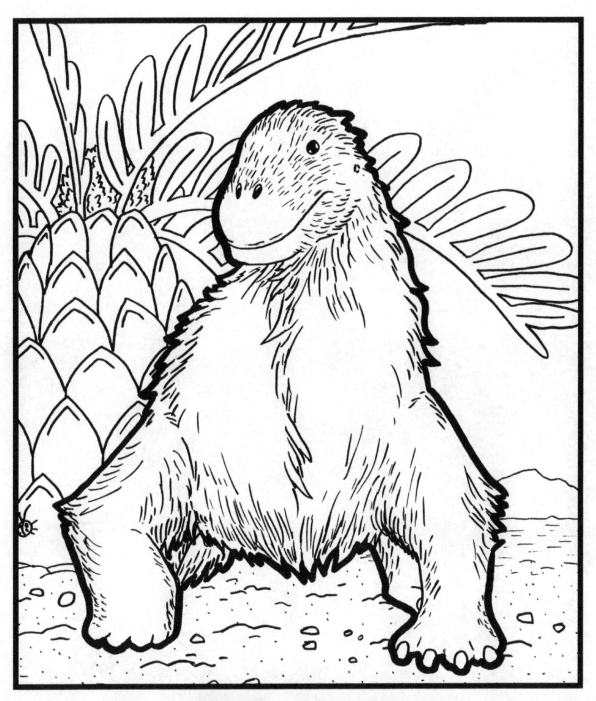

MOSCHOPS

265-260 MYA, Middle Permian, South Africa

This massive, slow-moving synapsid could grow up to 5 meters long, and fed mainly upon tough, nutrient-poor vegetation. As a result, it had to have spent most of its day eating. Its name also means "calf-face." It might have used its 10 centimeter-thick skull in dominace displays, where two individuals would push at one another with their heads.

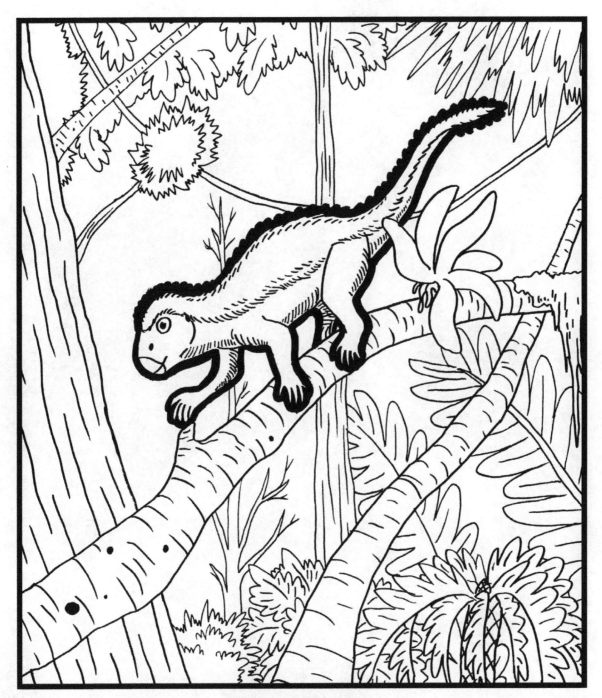

SUMINIA

260 MYA, Late Permian, Russia

It has been suggested that this small early synapsid was at least partly arboreal, owing to the hands being capable of grasping. If so, this would be the earliest arboreal vertebrate known so far. Heavy tooth-wear indicated that it was an herbivore, despite the teeth themselves being both large and sharp.

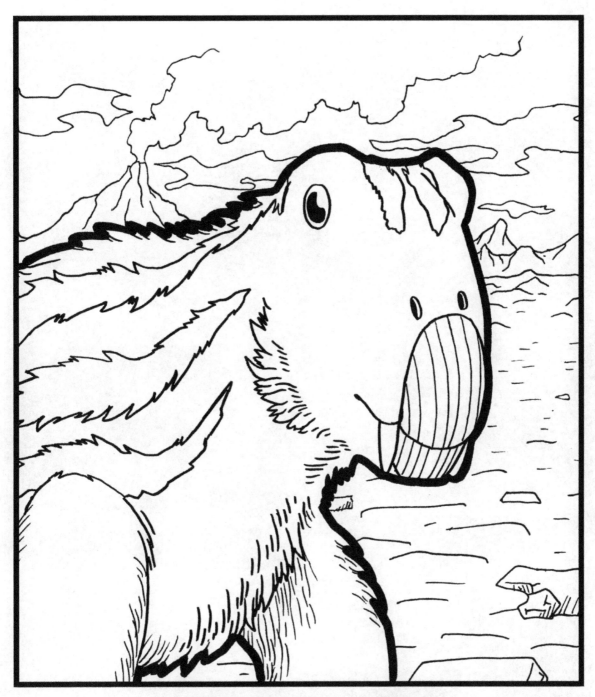

LYSTROSAURUS

255-250 MYA, Late Permian to Early Triassic, Antarctica, India, South Africa

An herbivorous therapsid, this "shovel-lizard" used its beak to cut away tough vegetation, and probably burrowed for food or shelter. During the Early Triassic they dominated the southern part of Pangaea, with up to 95% of all land-vertebrate fossil specimens belonging to this animal.

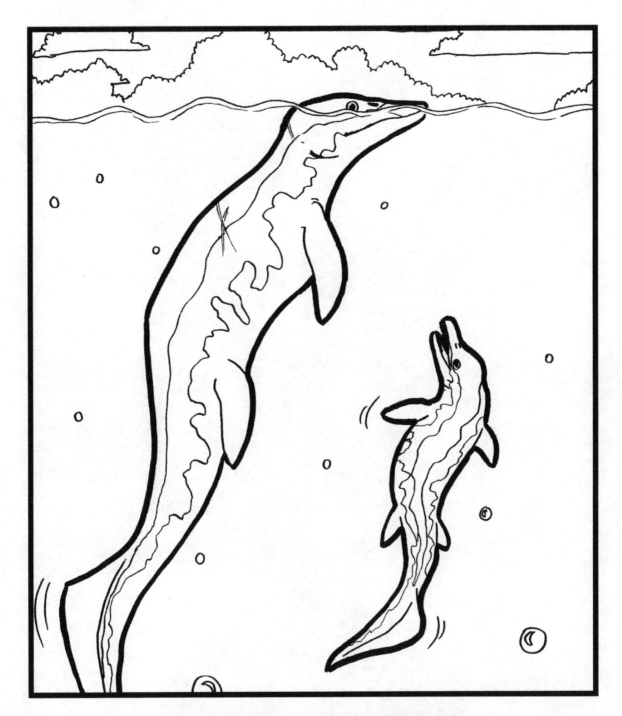

CHAOHUSAURUS

248 MYA, Early Triassic, China

This animal was an ancestor of the ichthyosaurs, marine reptiles with a dolphin-like shape. Compared to later species, the head was shorter, and the body more lizard-like. They did not lay eggs, but unlike later ichthyosaurs which are born tail-first to prevent suffocation, they were born head-first, which gave evidence for the terrestrial ancestor also bearing live young head-first.

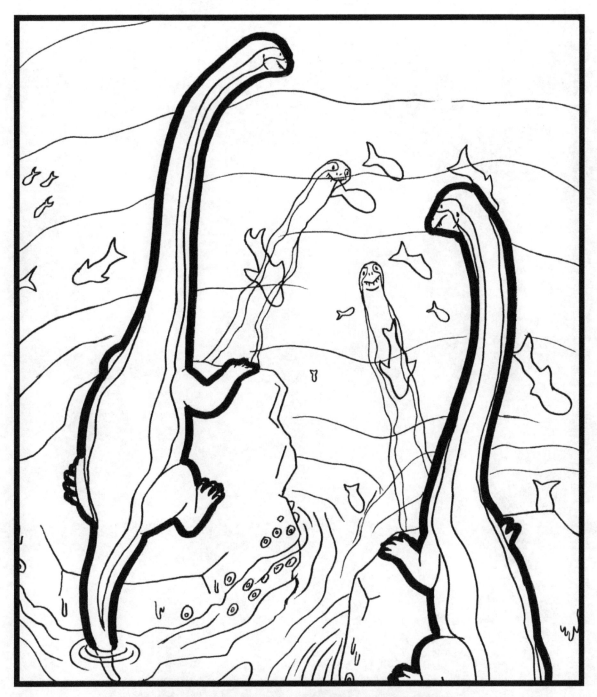

TANYSROPHEUS

245 - 228 MYA, Middle Triassic, Italy and China

This was a fish-eater with a neck that was longer than both its body and tail combined, giving a total length of around 6 meters. The neck was very stiff, made up of 12-13 extremely long vertebrae. It was also not very heavy, with most of the animal's mass being near the back, where the powerful hind limbs shifted the center of mass towards the back. This allowed it to easily swing its head at prey.

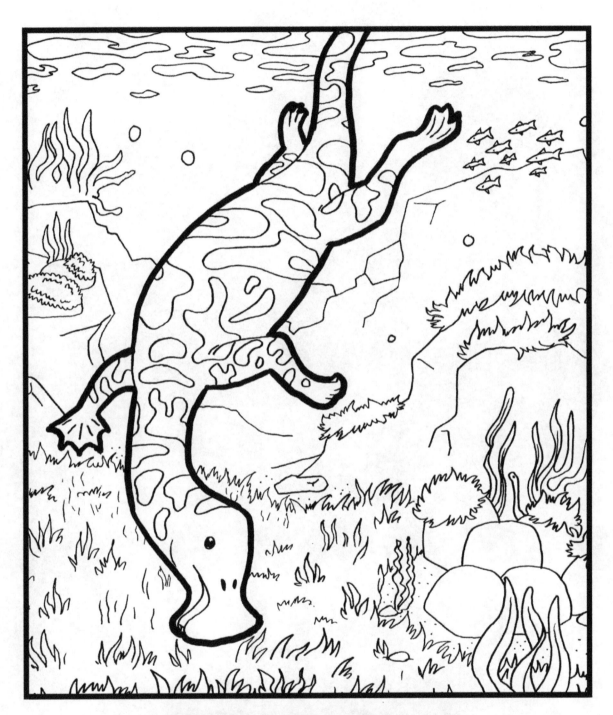

ATOPODENTATUS

240 MYA, Middle Triassic, Southwest China

This algae-eating marine reptile's odd, hammer-shaped head helped it root through the seafloor for food.
It is the earliest known herbivorous marine reptile, which is made even more unique when compared to most other marine reptiles, which tended to be omnivores or carnivores.

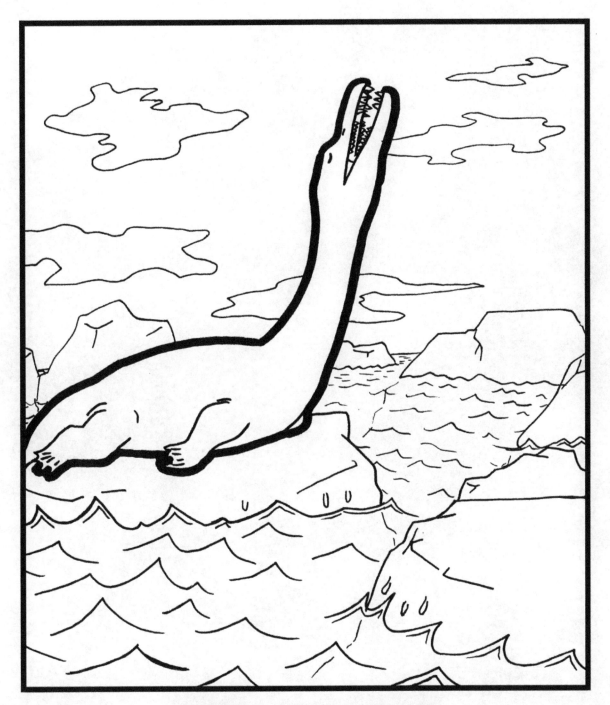

NOTHOSAURUS

240 - 210 MYA, Early to Late Triassic, Germany, Spain, China, Netherlands

Like modern-day seals, nothosaurus spent part of its time on land, and the other part in the sea. It is unknown if they gave birth to live young, or if they laid eggs, but there is evidence that suggests a common ancestor of both nothosaurs and ichthyosaurs was capable of live-births.

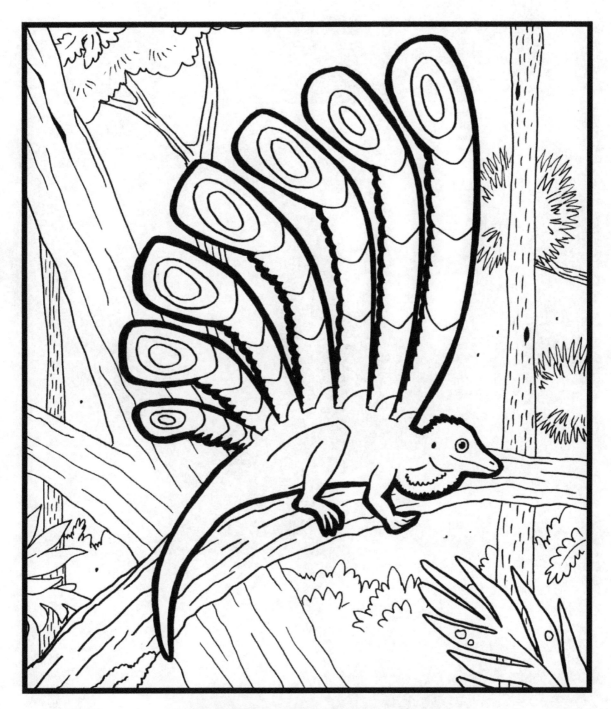

LONGISQUAMA

235 MYA, Mid Triassic, Kyrgyzstan

Since its discovery, the strange structure on this animal's back has been reconstructed as a sail, a pair of gliding wings, and even as a plant that happened to be preserved on top of it. A very prominent part of this little reptile, even its name means "long scales."

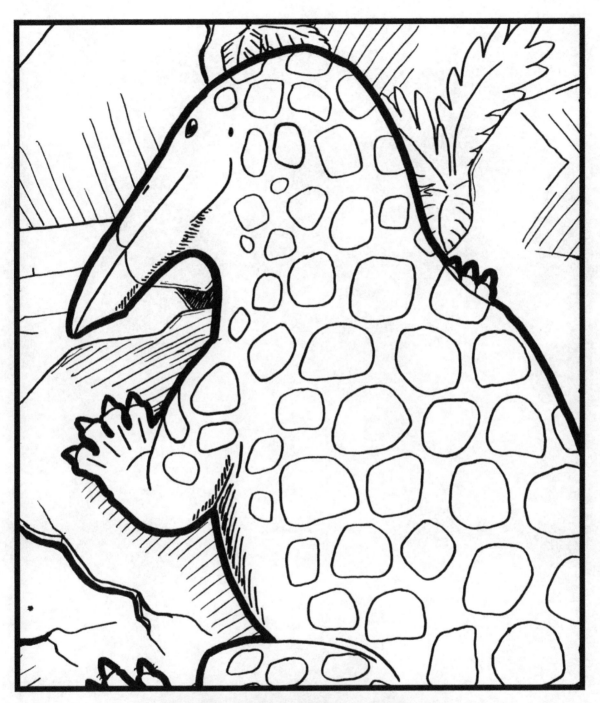

TERATERPETON

235 - 221 MYA, Late Triassic, Canada

Very different-looking from other reptiles of its time, the head was long and beak shaped, and lacked teeth on the ends.
It shared skull features with the marine reptiles, ichthyosaurs and plesiosaurs, but was not closely related to them.
It is not currently known what role this animal played in its ecosystem, so until more is known, it is up to speculation.

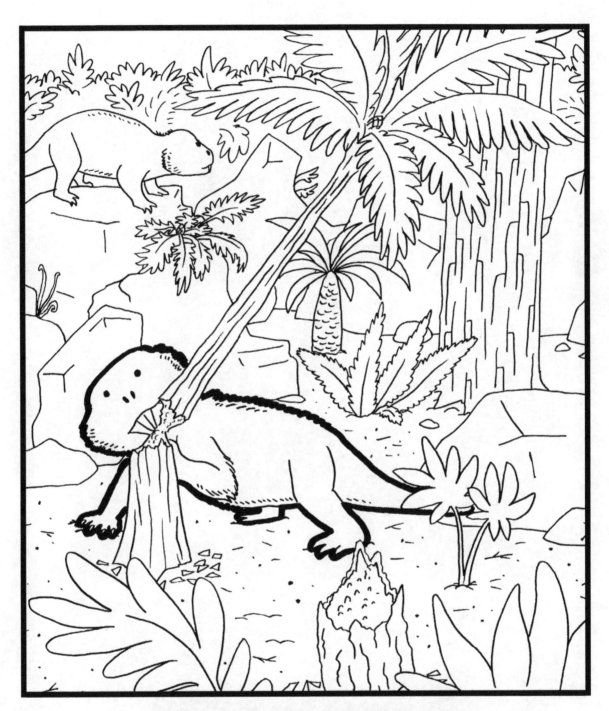

HYPERODAPEDON

231-216 MYA, Late Triassic, Argentina, Brazil, India, Scotland

These animals were small herbivores that were widespread throughout the supercontinent of Pangaea.
This had the result of their fossils being found on several of today's continents.
Its diet probably consisted of seed ferns, and it most likely died out when these plants became scarce.

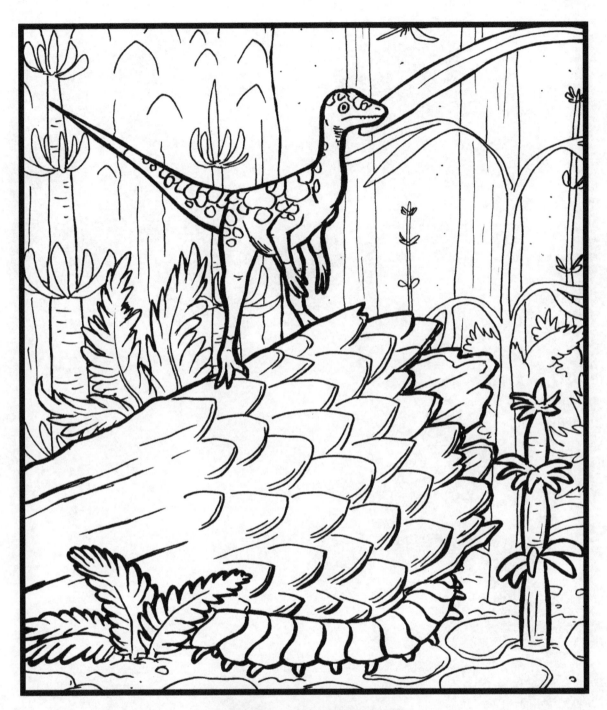

EORAPTOR

231 MYA, Late Triassic, Argentina

One of the first dinosaurs, eoraptor was a small, swift omnivore that stood on two legs. Its name means "dawn plunderer." During its time, dinosaurs were not yet the dominant land vertebrates they would eventually become.

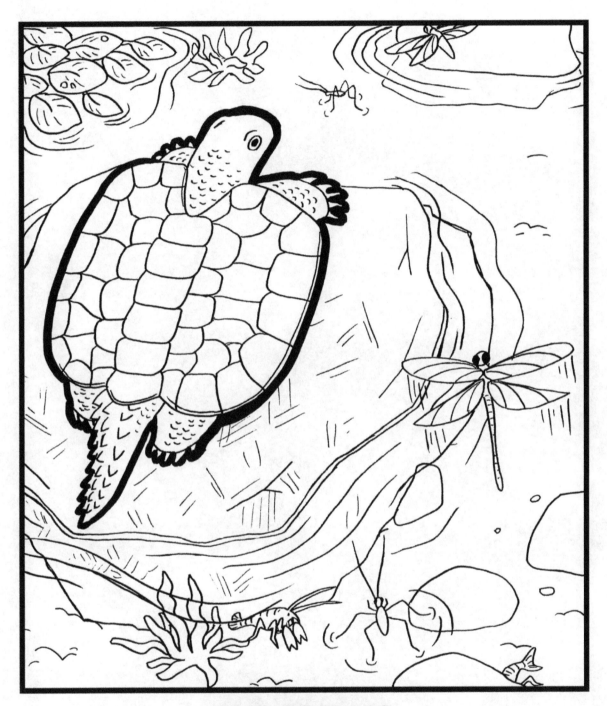

HENODUS

228-220 MYA, Late Triassic, Germany

This meter-long placodont looked very similar to a turtle, yet it bore no relation to them.
Its limbs were weak and made venturing onto land difficult, and its hammer-shaped jaws were suitable for filter-feeding and scraping plant
life off the bottom of the ponds and lakes it lived in.

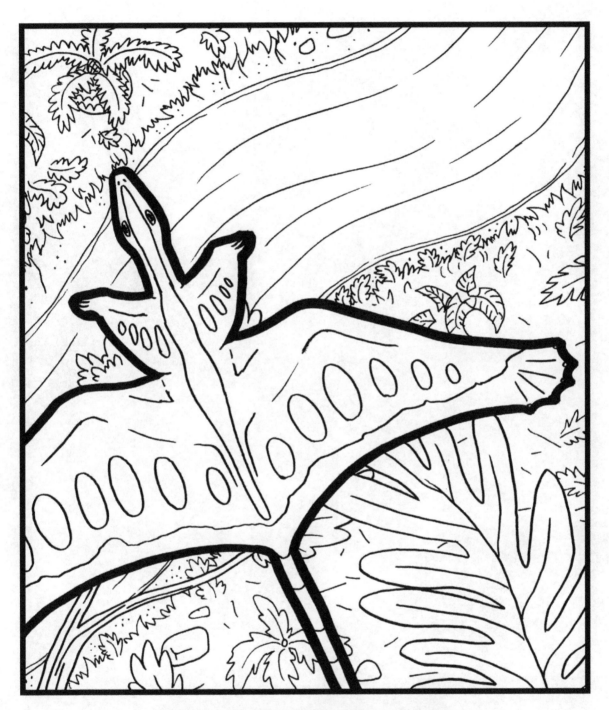

SHAROVIPTERYX

225 MYA, Middle to Late Triassic, Kyrgyzstan

This unusual early reptile was evolution's way of coming up with a novel way of travel by air. Where birds, bats, flying fish, and pterosaurs all use their front limbs or fins in an airfoil, this protorosaur used its hind limbs for that function. It would glide from tree to tree, using the membrane around its forelimbs to help steer its path.

XVI

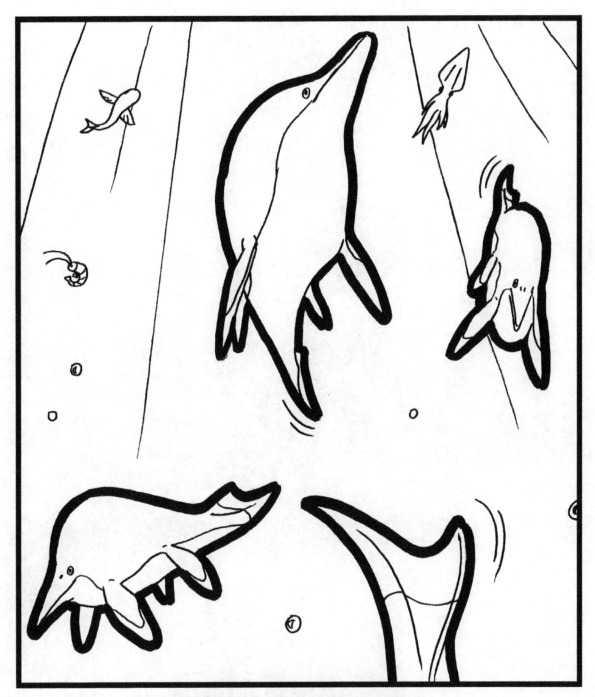

SHONISAURUS

221.5-212 MYA, Late Triassic, United States

Shonisaurus is one of the better known ichthyosaurs, and it owes this to the abundance of fossils left behind. The body was very deep and round compared to other marine reptiles, and it could reach a length of up to 15 meters. It did not have a dorsal fin, and the fluke of the tail wasn't quite as developed in this animal as it would be for later icthyosaurs.

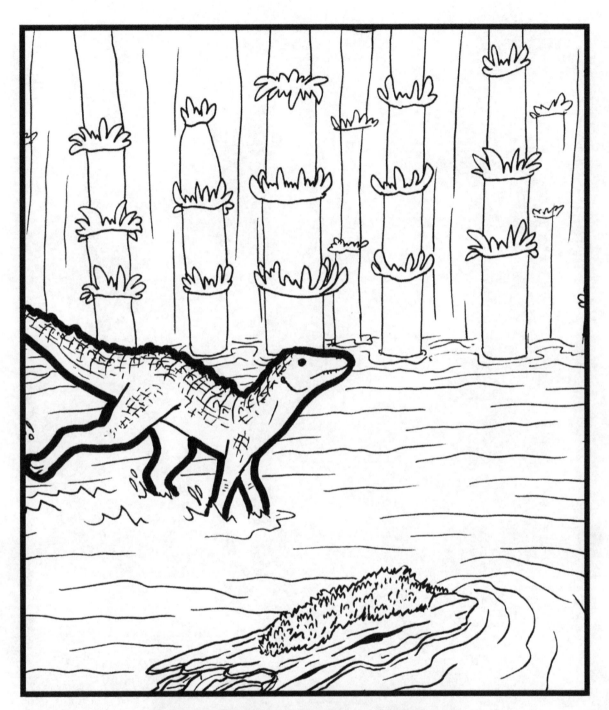

HESPEROSUCHUS

220 MYA, Late Triassic, North America

About a meter and a half long, this animal was a pseudosuchian, which were more closely related to crocodilians than to dinosaurs. They were capable of quickly running on all fours or with only the back legs, and the hands were useful for grasping, digging, and other activities requiring some level of dexterity.

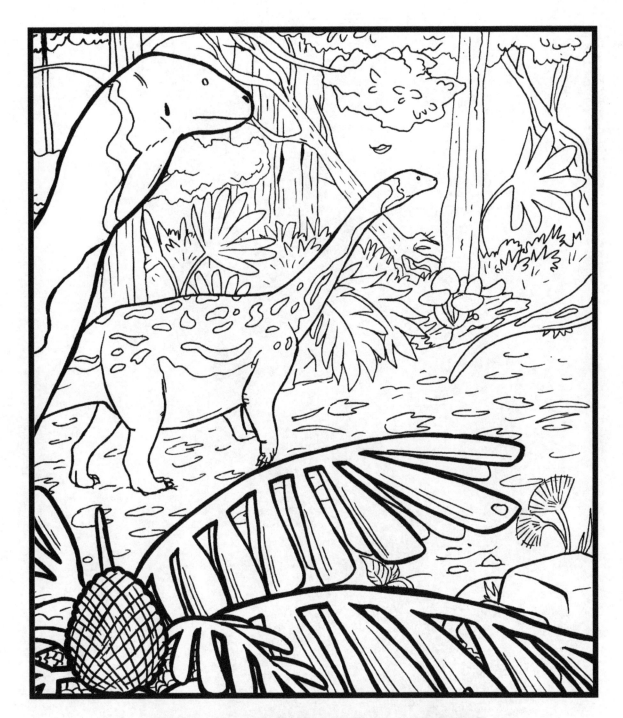

MELANOROSAURUS

216-201 MYA, Late Triassic, South Africa

This animal was a basal sauropod, which, at about 8 meters long, was still small compared to the behemoths the future would usher in. Despite this, it had a heavily-built body, robust limbs, and a small head, which would all be traits shared by many sauropods to come.

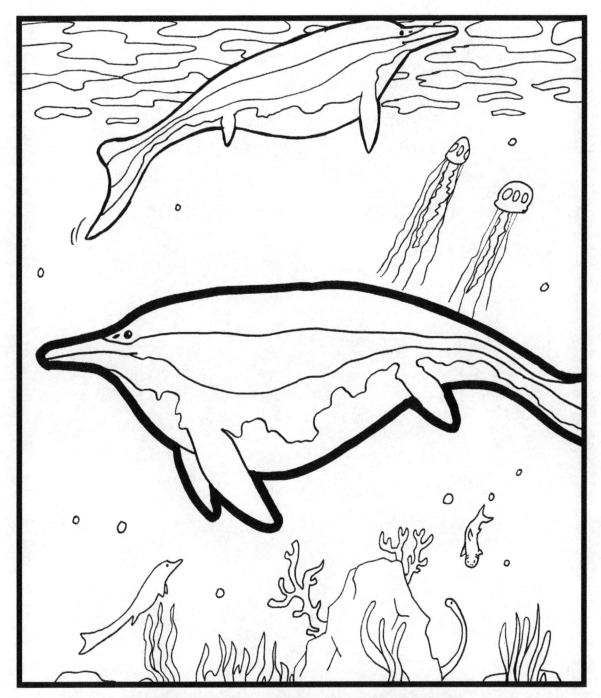

HIMALAYASAURUS

215.5-212 MYA, Late Triassic, Tibet

This giant ichthyosaur could reach a length of up to 15 meters, though it is only known from fragmentary remains. It was in the family Shastasauridae, which also included Shonisaurus. Unlike other ichthyosaurs, which had pointed, conical teeth, Himalayasaurus's teeth were large, flat, and suitable for cutting.

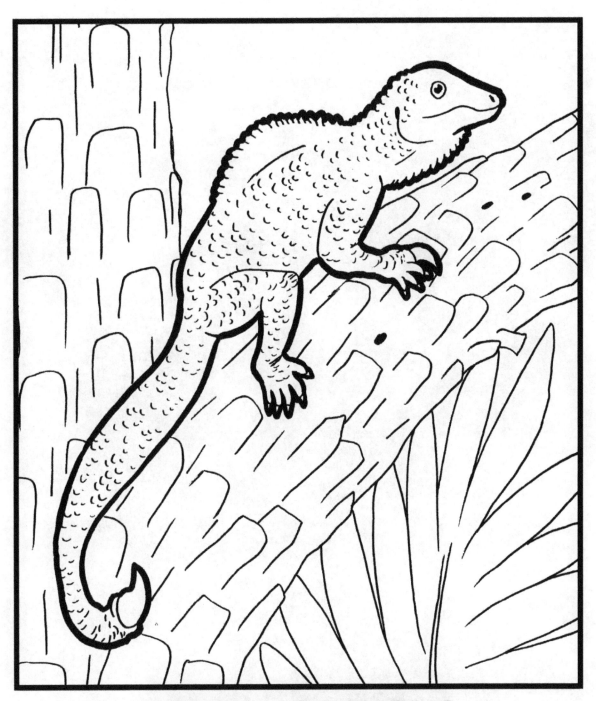

DREPANOSAURUS

212 MYA, Late Triassic, United States and Italy

These reptiles lived in trees, and even had prehensile tails to help them grip onto branches. This tail had a little claw at the end, assisting the animal with keeping its grasp on the tree. They were half a meter long and had a birdlike, triangular head. The large claw on its index finger likely helped it get to insects hiding within tree bark.

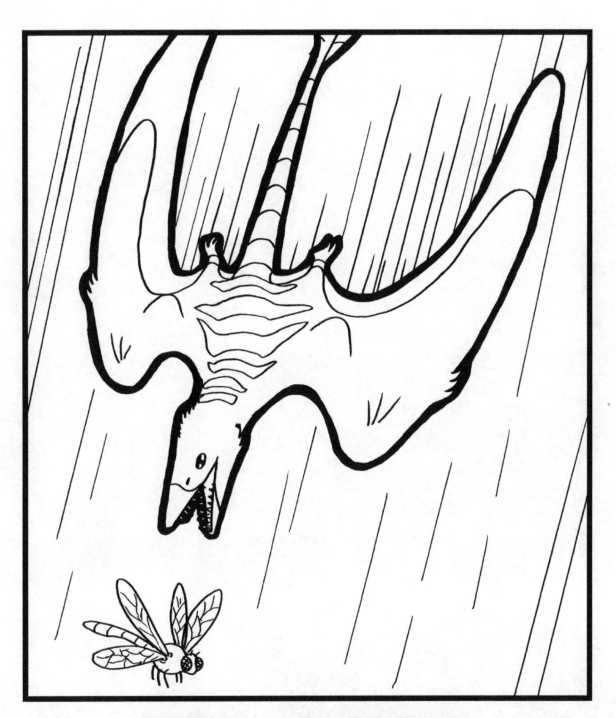

EUDIMORPHODON

210 - 203 MYA, Late Triassic, Italy, France, Luxembourg

A small pterosaur with a wingspan of just over a meter, its teeth had the best fit of all other pterosaurs when its mouth was closed. It is one of the most abundant fossils in Italy. It was also one of the earliest pterosaurs, and like many early members of the group, was a piscivore.

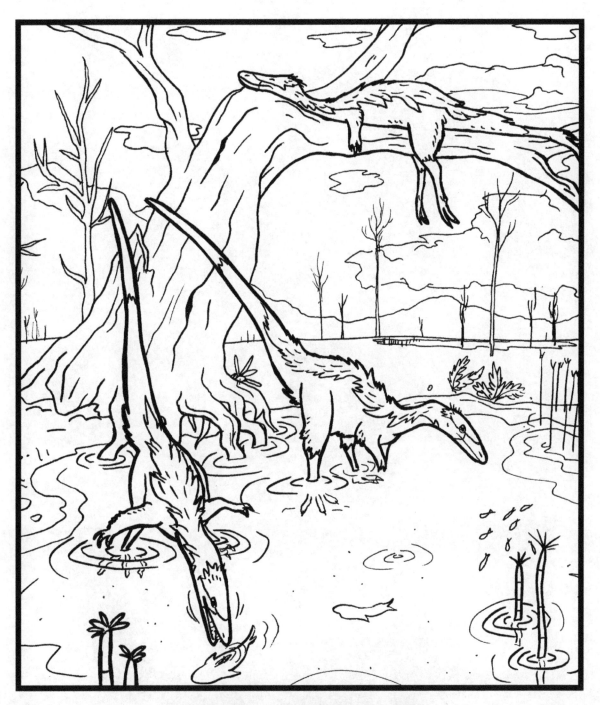

COELOPHYSIS

203-196 MYA, Late Triassic to Early Jurassic, United States

This 3 meter-long speedy carnivore had eyesight akin to the hawks and eagles of today, with excellent color vision and poor low-light vision. They hunted small, fast moving prey, and may have ventured into shallow water to catch fish. Their environment consisted of floodplains with distinct wet and dry seasons.

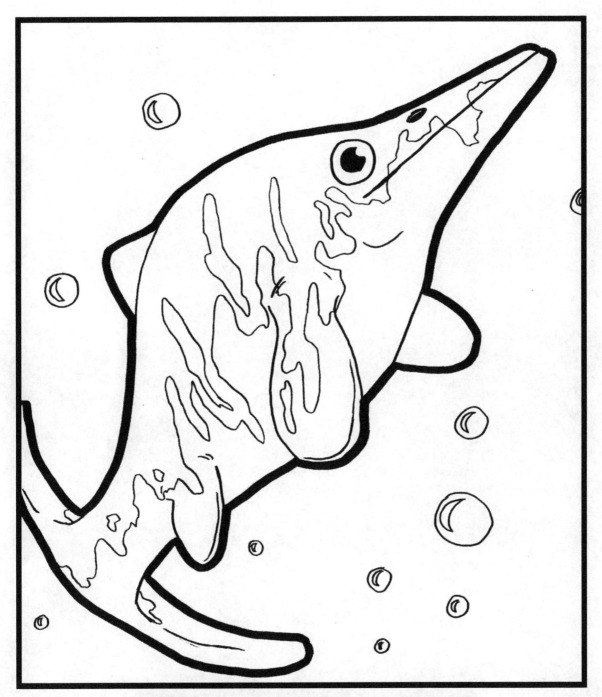

OPTHALMOSAURUS

201.5-145.5 MYA, Jurassic, England, France, Greenland, Mexico, United States

At 6 meters long, this common, dolphin-shaped squid-eater lived through almost the entire Jurassic period. Its eyes had a diameter of 23 centimeters, and took up nearly all of the space inside the skull, with even the name of this "eye-lizard" referencing their size. These huge eyes allowed them to hunt in deep waters or at night, when squid tend to be active.

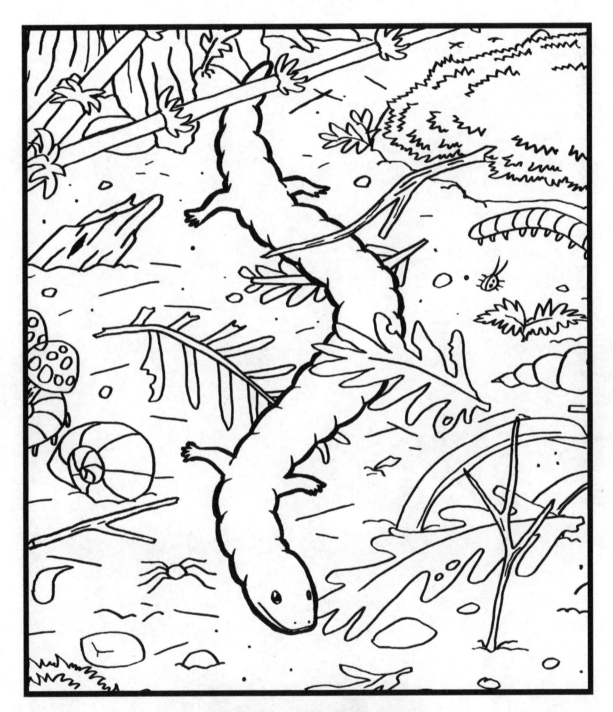

EOCAECILIA

199.6 - 175.6 MYA, Early Jurassic, United States

Although it appeared to look like some sort of snake ancestor, this was an amphibian that likely lived in leaf litter, searching for invertebrates and staying out of sight of larger animals. It reached a length of up to 15 centimeters, and the fossil specimen of this animal was remarkably well-preserved for something as ancient as it.

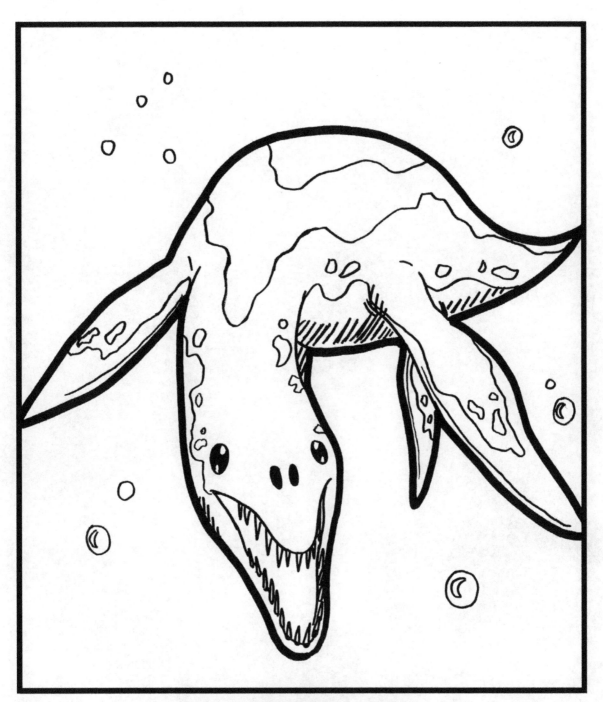

MACROPLATA

199-195 MYA, Early Jurassic, England

Compared to other pliosaurs at the time, this marine reptile had a long neck that was twice as long as its skull. It lived off a diet of fish, and used its powerful swimming muscles to lunge at individuals that broke away from synchronized shoals.

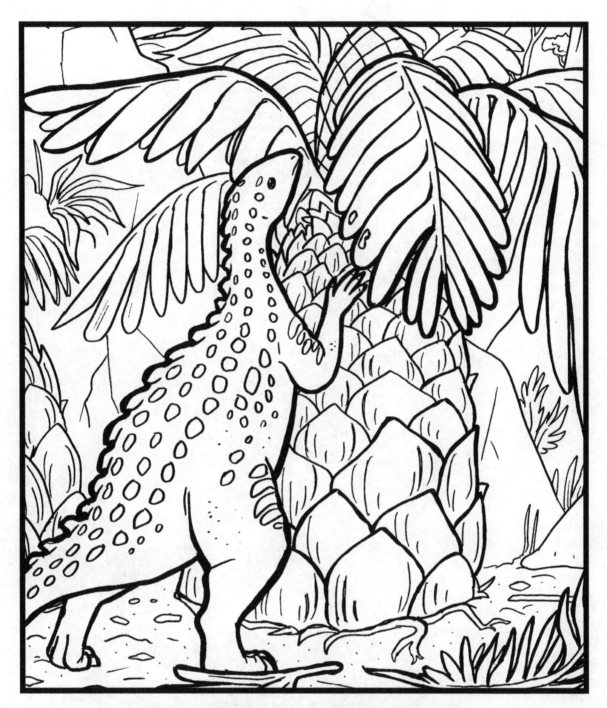

SCUTELLOSAURUS

196 MYA, Early Jurassic, United States

This early "little shielded lizard" had several hundred osteoderms running down the length of its back and tail.
Despite this, it was a small, lightly-built bipedal herbivore, at just over a meter long.

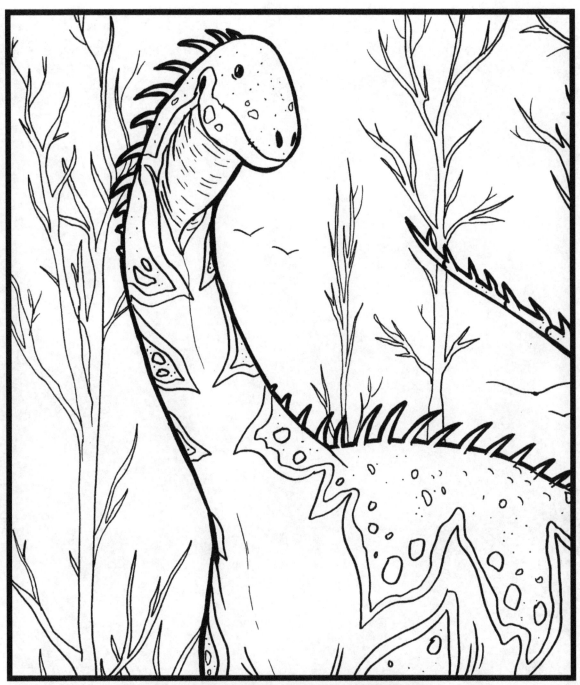

BARAPASAURUS

196-183 MYA, Early Jurassic, India

A sauropod with one of the most completely known skeleton of its group in the early Jurassic, the size of Barapasaurus was comparable to later members, at around 14 meters in length. Even this early in sauropod evolution, the skeleton showed hints of developing ways of overcoming the stresses of its body's sheer weight, such as the hollowing of the vertebrae.

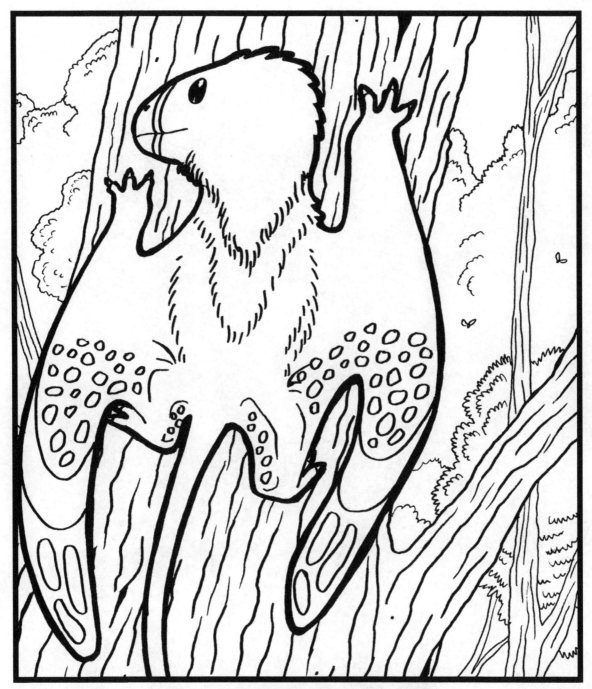

DIMORPHODON

195 - 190 MYA, Early Jurassic, Mexico, England

This pterosaur was active on the ground, in the air, and was even adept at climbing trees. Before its was discovered, it was assumed that pterosaurs, along with many other prehistoric animals, were sluggish, unintelligent beasts that were fated to extinction. Its well-developed limbs showed that it could get around on the ground or in the trees just fine.

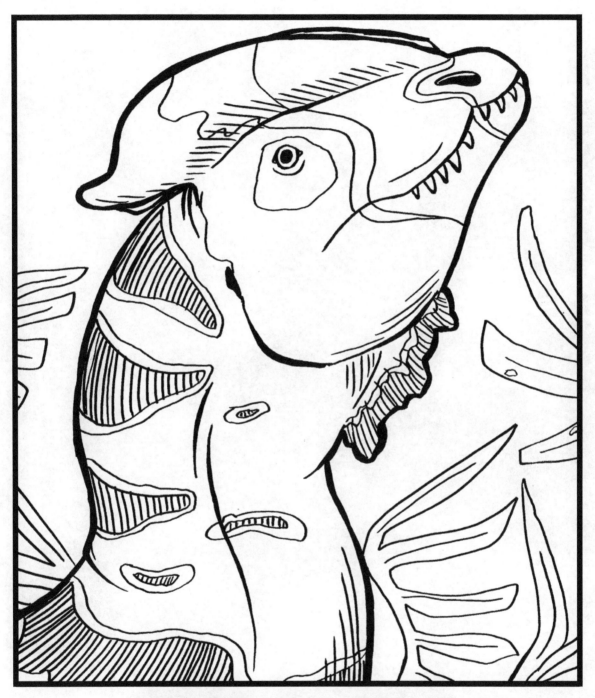

DILOPHOSAURUS

193 MYA, Early Jurassic, United States

This predator was one of the largest carnivorous dinosaurs of its time, at 7 meters in length. No significant differences have been found between fossils that would suggest dimorphism between male and female skeletal systems. Because of similarities it seems to share with spinosaurs and its proximity to water in life, it has been suggested that it was a piscivore.

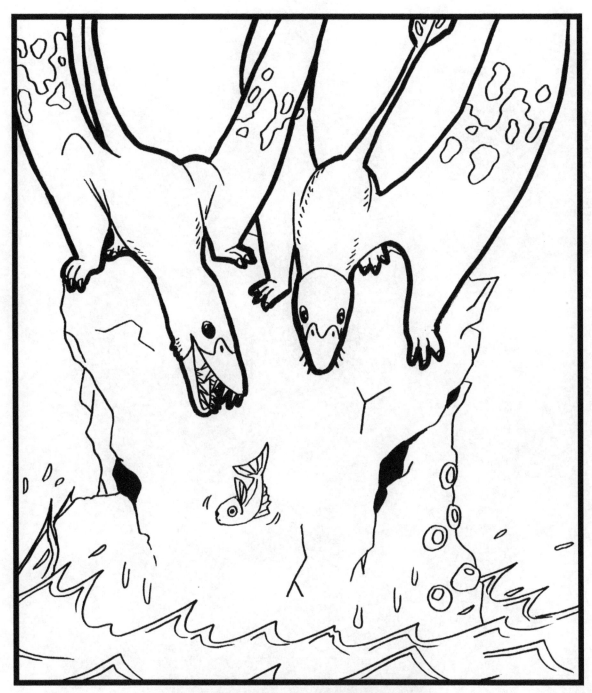

DORYGNATHUS

180 MYA, Early Jurassic, Germany and France

This pterosaur's most notable trait were its long, conical teeth, which pointed away from the mouth, which it used to hold onto slippery fish, squid, and other sea creatures. It was also a member of the Rhamphorhynchinae, a family of long-tailed, short necked pterosaurs that also generally lacked a bony crest on the head.

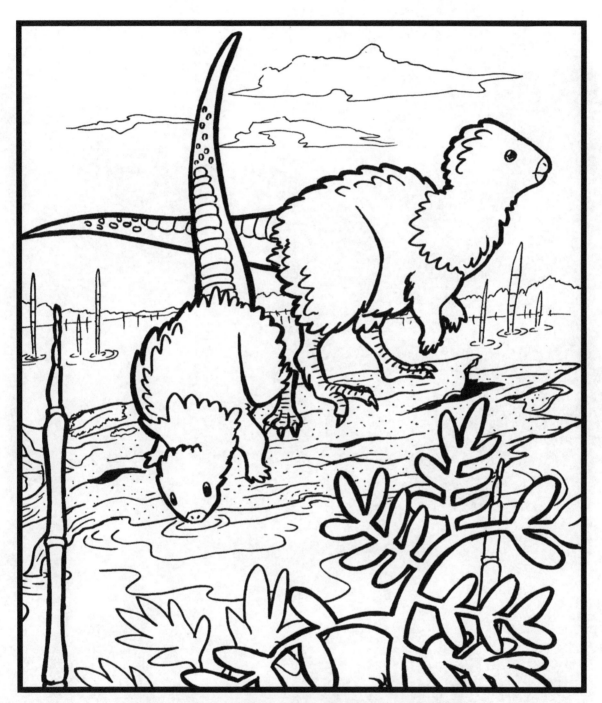

KULINDADROMEUS

169-144 MYA, Middle to Late Jurassic, Russia

This little herbivore was 1.5 meters long, and had a body covered by a layer of dinofuzz, while its tail had a scaley covering.
This discovery of an ornithischian dinosaur having a feathery coat points at this trait originating in a shared common ancestor of both
bird-hipped and lizard-hipped groups of dinosaur, rather than being exclusive to the theropods.

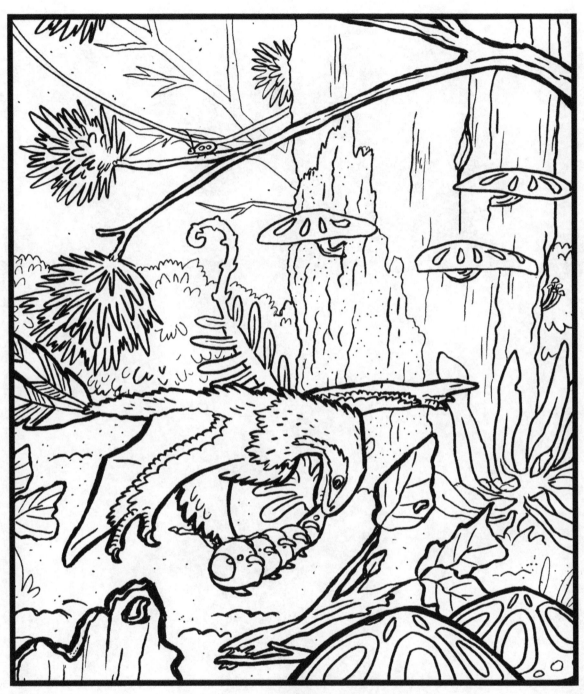

YI

160 MYA, Middle Jurassic, China

Yi is not only notable for having the shortest genus name of any dinosaur, but for the way its wings are presented. Yi had a feathery coating, and bones at its wrist supported a membrane that may have been used in gliding, with some flapping to control its descent. This was a very small dinosaur, weighing less than 400 grams.

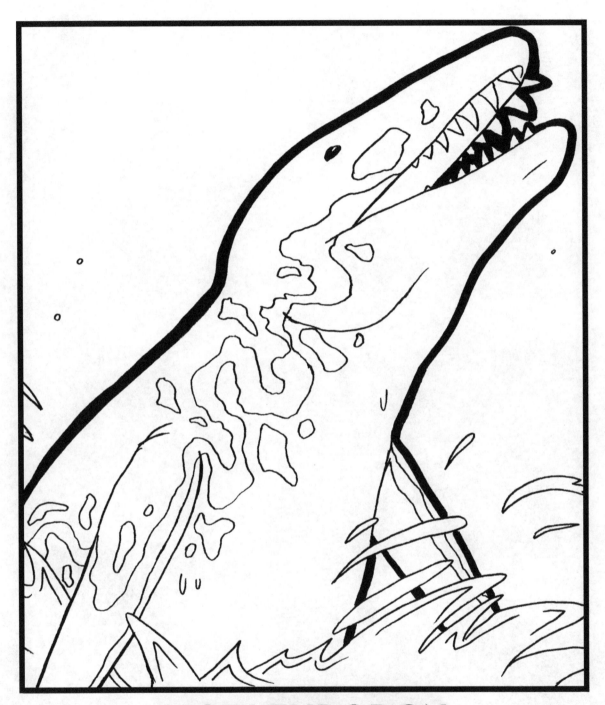

LIOPLEURODON

160-155 MYA, Middle to Late Jurassic, England, France, Germany, Argentina, Mexico

Many specimens of this Jurassic apex predator have been discovered. Its head was a fifth of the total size of its body, and was filled with long and strong conical teeth. It used its sense of smell to find its prey, which it would ambush in a quick burst of speed.

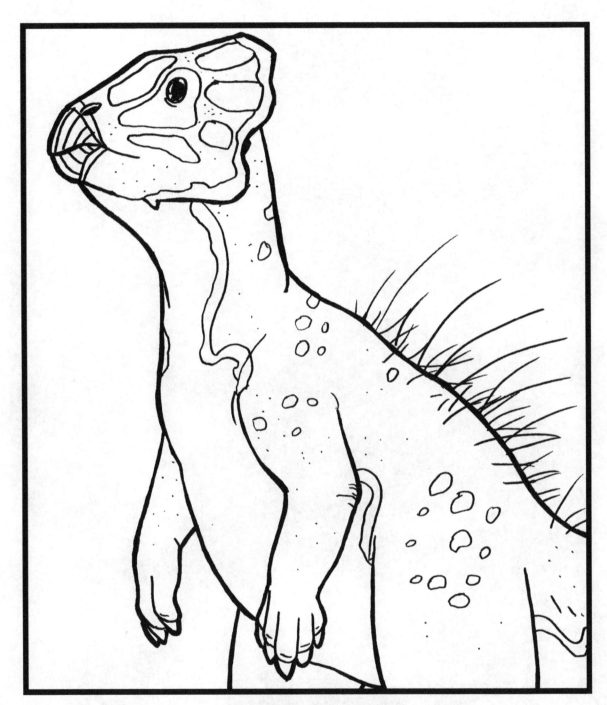

YINLONG

158 MYA, Late Jurassic, China

At just over a meter long, this ancestor to the ceratopsians was much smaller than many of its future descendants.
The crest wasn't nearly as pronounced as it would become in time, and this little generalist herbivore was still a bipedal dinosaur.
It might have had a set of quills along its tail and back, as some later species would be discovered with evidence of such.

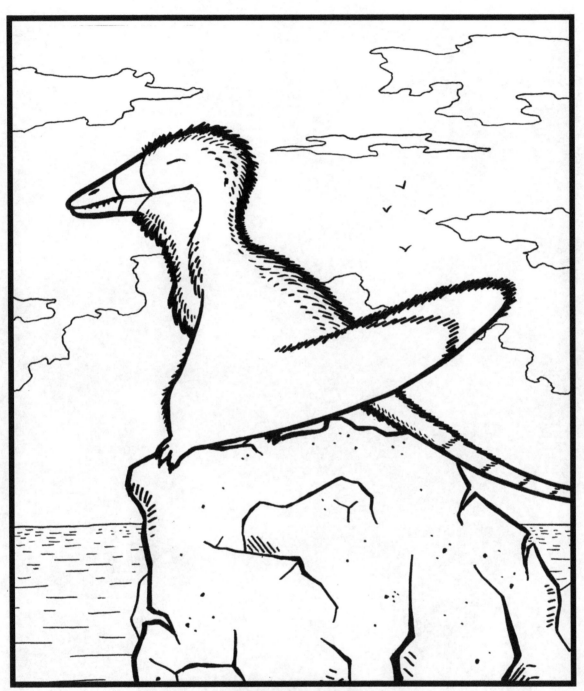

SORDES

155.7 MYA, Late Jurassic, Kazakhstan

This was the first pterosaur fossil to be discovered with direct evidence for a thick covering of fuzz, called pycnofibers.
Today we know that all pterosaurs had this type of covering on nearly their entire bodies. This tiny short-necked pterosaur's tail was over
half of its total length, and it also lacked a head-crest. It probably lived off of insects and small vertebrates

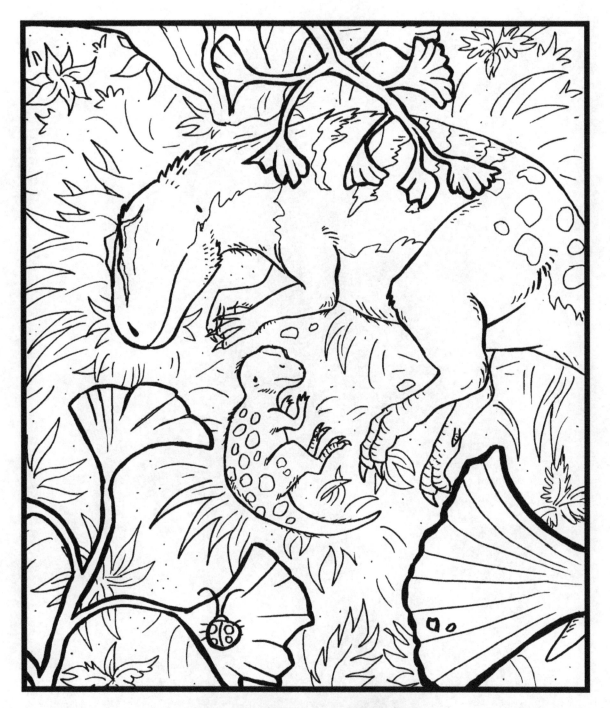

ALLOSAURUS

155-150 MYA, Late Jurassic, United States, Portugal

A large bipedal predator averaging 8.5 meters in length, Allosaurus is one of the better-known, and more common, theropods.
It wasn't as built for speed as other theropods, but was better suited as an ambush predator in its semiarid, floodplain, environment.

CPSIA information can be obtained
at www.ICGtesting.com
Printed in the USA
BVHW061447220621
610213BV00002B/273